Klee *as in* clay

A Pronunciation Guide

**Compiled, written and edited
by Wilfred J. McConkey**

Contents

Copyright © 1986 by

Hamilton Press

4720 Boston Way
Lanham, MD 20706

3 Henrietta Street
London WC2E 8LU England

Printed in the United States of America

Library of Congress Cataloging in Publication Data

McConkey, Wilfred J.
 Klee as in clay.

 Includes index.
 1. Artists—Registers. 2. Names—Pronunciation.
I. Title.
NX163.M3 1986 700'.92'2 86-18309
ISBN 0-8191-5620-5 (alk paper)
ISBN 0-8191-5621-3 (pbk. : alk. paper)

All Hamilton Press books are produced on acid-free
paper which exceeds the minimum standards set by the National
Historical Publication and Records Commission.

Hamilton Press

Introduction

The predominance of foreign names in the arts has always posed pronunciation problems for Americans. And it is scant consolation to realize that people of all nationalities face their own version of the same problems.

It's not surprising then that so many of the names on our most-frequently-mispronounced list are foreign to Americans whatever their ancestry.

Other names make the list because they defy pronunciation logic or are open to more than one phonetic interpretation. (Is Cather pronounced *cayther, cawther,* or like *gather?* Does the *th* sound like the one in *thought* or in *though?*)

Whatever the particular problem each name in the guide presents, the result is that it is mispronounced often—either in relation to or by virtue of the number of times it crops up in conversation.

Marcel Breuer, for instance, despite his important contributions to 20th Century architecture, is seldom spoken of outside art and design circles. But when he is, his surname is almost invariably mispronounced.

Author Lawrence Durrell, on the other hand, is a popular subject of discussion. As a result, his name, even though it is said incorrectly only a small percentage of the time, still qualifies as "frequently mispronounced."

Some names suffer on both counts: high error rate and frequent mention. Notable examples are Heinrich Böll, Raoul Dufy and Leonard Bernstein. Oddly enough, the latter even gets abused by disk jockeys on classical music stations—normally a most fastidious group.

Useful and easy to use. These were the twin objectives set for this guide and, together, they dictated content, treatment and format.

To make pronunciations easy to grasp, only common words and phonetic spellings are used to indicate the appropriate sounds. Many readers will find the absence of phonetic symbols a welcome relief. The trade-off is that some nuances, particularly in the pronunciation of certain German names, are sacrificed. However, where these shadings have not already been eliminated in the process of "Americanization," instructions on how to produce them are included (see Goethe, page 17).

Also absent are Picasso, Schubert, Strauss, Johns, Johnson, Shakespeare, Pollack and hundreds of other illustrious names. They were excluded purposely because, being famous, common or straightforward, they are infrequently if ever mispronounced. Thus, if a significant name doesn't appear in this guide, there should be no doubt how to say it.

For the sake of usefulness, the criterion applied in recommending pronunciations is *acceptability by knowledgeable North Americans*. Assuredly, this standard is easier to assert than to defend. By definition it is only reliable to the extent that these mavens can be identified and vetted, and that anything approaching a consensus within their ranks can be ascertained. But, by and large, the problems are more theoretical than real.

About the vast majority of entries there is little or no controversy and, where disputes arise, drawing straws may provide as authoritative an answer as can be found. Example: How should novelist Anaïs Nin's first name be pronounced? A respected American encyclopedia says *uh-nigh-is*. Her long-time friend, Lawrence Durrell (certainly knowledgeable, but not an American), renders it *an-i-eece*. And the author herself gave instructions to pronounce it *anna-ees*. The reader, mindful that it's a question of acceptability rather than correctness, can decide.

As a skim through this guide will show, qualifications for acceptability are anything but constant for foreign names. In some instances strict fidelity to the original pronunciation is demanded, in others comfortable corruption is

indulged. And sometimes, as in the case of Sir Georg Solti, both approaches have been taken in turn: Georg has become George, but Solti must still be pronounced *shoal-tee.*

There are cases where the community of knowledgeable North Americans has been tardy in reaching a decision, and some in which its pronouncements were overruled by the masses. Remarkably, the winner of the 1980 Nobel prize for literature falls in the first category. In his native tongue, his name, Czelaw Milosz, comes out *chess-wahv me-wash*, sounds few Americans associate with the Lithuanian-born poet and novelist. And, although he emigrated to the U.S. more than two decades ago, there was no authoritative recognition that an acceptable Americanized pronunciation of his name existed until the first edition of this book was published in 1985.

Other emigres pose special problems, too.

Kurt Weill, the German composer, spent the last 15 years of his life in the U.S. In his native land his name is pronounced *vile.* But millions of Americans who saw his name on song sheets and movie and theater credits—without ever hearing it pronounced correctly—did what came naturally. They called him *wile*, and the force of numbers prevailed, eventually giving legitimacy to that pronunciation in America.

The case of the expatriate Austrian writer Franz Werfel was different. Few of the millions of Americans who enjoyed his novel, The Song of Bernadette, pronounced his name *vair-ful.* But the litterati did, and they prevailed.

Richard Wagner and Carl Maria Von Weber, on the other hand, were never in serious danger of having their names Americanized. Probably because they stayed at home.

So, the warning to Germanics seems clear: prepare to surrender your VWs all ye who enter here.

The guide is intended for use in the U.S. and Canada as a handy reference and as a self-examination kit for pronunciation gaffes.

Pronunciation keys

· Pronunciations appear in parentheses.
· Boldface type indicates emphasis.
· Common words are used whenever possible to indicate how a name, or a part of a name, should be pronounced. Phonetic spellings are used only when words fail.

If a combination of letters spells a common word, like *me* or *knee* for example, it is the sound of that word that's called for.

· When a letter combination isn't immediately recognizable as a common word, treat it as phonetic spelling.
· A *zh* indicates that the sound of the French *je (*as in *je vous aime)* is called for.

Architecture

BREUER, Marcel
(broy•ur)

b. 1902
Hungarian-American architect

BRUNELLESCHI, Filippo
(brew•nell•**less**•key)

1377-1446
Florentine architect

CANDELA, Felix
(con•**day**•la)

b. 1910
Mexican architect

CUVILLIÉS, Francois
(cue•vee•**ess**)

1695-1768
Walloon architect

CUYPERS, Petrus
(**coy**•purse)

1827-1921
Dutch architect

EAMES, Charles
(eems)

1907-1978
American designer and architect

EIERMANN, Egon
(**eye**•ur•mahn)

1904-1970
German architect

GAUDÍ, Antonio
(gow•**dee**)

1852-1926
Spanish architect

GILLY, Friederich
(zhil•ee)

1772-1800
German architect

GIURGOLA, Romaldo
(joor•go•la)

b. 1920
American architect

GOERITZ, Mathias
(gur•its)

b. 1951
German sculptor and architect living in Mexico

GROPIUS, Walter
(grow•pee•us, valter)

1883-1969
German architect

GRUEN, Victor
(grun)

1903-1980
Austrian-born American architect

GUIMARD, Hector
(gee [as in geek]•mar, ek•tor)

1867-1942
French architect

HARDOUIN-MANSART, Jules
(ar • dwan, mansahr)

1646-1704
French architect

HAUSSMAN, George Eugène, Baron
(owes•mon)

1809-1891
French urban planner

HEJDUK, John
(hay•duke)

b. 1929
American architect

HERRERA, Juan de
(ay•**ray**•rah)

1530-1597
Spanish architect

HILDEBRANDT, Johann Lukas von
(**hilda**•bront)

1668-1745
Austrian architect

HOLLEIN, Hans
(**haul**•yun)

b. 1934
Austrian architect

JOCOBSEN, Arne
(**yaw**•cope•sen, •**ar**•nuh)

1902-1971
Danish architect

KIESLER, Frederich John
(**keys**•lur)

1896-1965
Austrian architect

LeCORBUSIER
(core•boozy•**ay**)

1887-1965 Born Charles Edouard Jeanneret
Swiss-French architect

LOOS, Adolf
(lows)

1870-1933
Austrian Architect

LUTYENS, Sir Edwin Landseer
(luchenz)

1869-1944
British architect

MIES VAN DER ROHE, Ludwig
(mees•van•dare•**roe**•uh, **loot**•vic)

1886-1969
German architect

OUD, Jacobus Johannes Pieter
(owt)

1890-1963
Dutch architect

PEI, I.M.
(pay)

b. 1917
Chinese-American architect

PERRET, Auguste
(pair•ay)

1874-1954
French architect

ROCHE, Kevin
(roach)

b. 1922
Irish-born architect

VAUX, Calvert
(vox)

1824-1895
English architect who emigrated to the U.S.

Literature and Drama

AGEE, James
(ay•jee)

1909-1955
American poet, novelist, essayist and screenwriter

ALEICHEM, Sholem
(a • leh • hem)

1859-1916
Pen name of Solomon Rabinowitz, Ukranian-born
Yiddish novelist, playwright and short story writer

ANGELL, Roger
(angel)

b. 1920
American writer and editor

ANOUILH, Jean
(ah•new•ee)

b. 1910
French dramatist

BARTHELME, Donald
(bar•tull•me)

b. 1931
American novelist and short-story writer

BARTHES, Roland
(bart)

1915-1980
French literary critic and essayist

BATAILLE, Henry
(bah•tie)

1872-1922
French dramatist

BAUDELAIRE, Charles
(bode•lair)

1821-1867
French poet

BECHER, Johannes
(besh•ur)

1891-1958
German poet

BOCCACCIO, Giovanni
(bo•**caw**•cho)

1313-1375
Italian novelist

BÖLL, Heinrich
(burl [preferably with a silent r])

1917-1985 German author, winner of the Nobel
Prize for literature in 1972

BORGES, Jorge Luis
(**bore**•hays, **hoar**•hay, loo•ease)

1889–1986
Argentinian poet and essayist

BRECHT, Bertold
(brekht, **bare**•told)

1898-1956
German poet and playwright

BRETON, André
(bre•**tone**)

1896-1966
French poet, essayist, critic and editor

BRIEUX, Eugène
(bree•**oo**)

1858-1932
French dramatist

BROUN, Heywood
(broon)

1888-1939
American newspaper columnist

BUZZATI, Dino
(boo•**tsah**•tee)

1906-1972
Italian novelist and playwright

COZZENS, James Gould
(cousins)

1903-1978
American novelist

CREASEY, John
(**cree**•zee)

1908-1973
English mystery writer

CRÉBILLON, Prosper de
(cray•bee•**own**)

1674-1762
French dramatist

DaPONTE, Lorenzo
(dah•**pawn**•tay)

1749-1838
Italian poet and librettist

D'ANNUNZIO, Gabriele
(don•**noont**•see•oh, gabree•**ay**•lay)

1863-1938
Italian poet, playwriter, novelist and patriot

DANTE, Alighieri
(**don**•tay, olly•**gyay**•ree)

1265-1321
Italian poet

DAUDET, Alphonse
(doe•**day**)

1840-1897
French novelist, dramatist and short-story writer

DeKRUIF, Paul
(da•**kreef**)

1890-1971
American author and bacteriologist

DIDEROT, Denis
(deed•**roe**, duh•**knee**)

1713-1784
French philosopher, essayist and critic

DINESEN, Isak
(**dee**•nuh•sun, **ee**•sock)

1885-1962
Danish author

DIOP, David
(dee•**ope**)

1927-1960
African poet

DOS PASSOS, John
(dose•**pass**•us)

1896-1970
American novelist

DREISER, Theodore
(**dry**•sir)

1871-1945
American novelist

DUHAMEL, George
(do•ah•**mell**, zhorzh)

1884-1966
French novelist and poet

DUMAS, Alexandre
(do•**maw**)

1802-1870
French novelist

DURRELL, Laurence
(durl)

b. 1912
English novelist, poet, essayist and travel writer

DÜRRENMATT, Friedrich
(**dour**•en•mott)

b. 1921
Swiss novelist and playwright

ECO, Umberto
(echo, oom•**bare**•toe)

b. 1932
Italian author and professor of Semiotics

EHRENBURG, Ilya Grigorievich
(**ay**•ren•boork, eelya)

1891-1967
Russian journalist and novelist

ÉLUARD, Paul
(ay•loo•**ar**)

1895-1952
French poet

EMINESCU, Mihail
(em•een•**es**•coo)

1850-1889
Romanian poet

FARQUE, Léon Paul
(farg)

1876-1947
French poet

FEDIN, Konstantin Aleksandrovich
(fee•ed•**een**)

1892-1977
Russian novelist

FEUCHTWANGER, Lion
(**foysht**•vonger, **lee**•own)

1884-1958
German novelist and playwright

FEYDEAU, George
(fay•**doe**, zhorzh)

1862-1921
French dramatist

FLAUBERT, Gustave
(flow•**bare**)

1821–1880
French novelist

FOWLES, John
(fouls)

b. 1926
English novelist

FRANCE, Anatole
(fronce, ah•nah•**toll**)

1844-1924
French novelist, poet and critic

FRÉCHETTE, Louis Honoré
(fray•**shet**)

1839-1908
French-Canadian poet

GARCÍA LORCA, Frederico
(gar•**thia**)

1898-1936
Spanish poet and dramatist

GENET, Jean
(zhuh•**nay**, zhon)

1910-1986
French novelist and playwright

GEORGE, Stefan
(**gay**•or•guh, **shtef**•on)

1868-1933
German poet

GIDE, André
(zheed, ondray)

1869-1951
French novelist and playwright

GIONO, Jean
(joe•**no**)

1895-1970
French novelist

GIRAUDOUX, Jean
(zhee•roe•**do**, zhon)

1882-1944
French playwright and diplomat

GIROUX, André
(zhee•**roo**)

b. 1916
French-Canadian novelist and scriptwriter

GJELLERUP, Karl Adolph
(yell•ur•up)

1857-1919
Danish novelist and poet

GOETHE, Johann Wolfgang von
(gerta [preferably with a silent r])

1749-1832
German poet and novelist

GOGOL, Nikolai
(go•gull)

1809-1852
Russian novelist

GRASS, Günter
(graws•gun•tur)

b. 1927
German novelist, poet and playwright

GRAU, Shirley Ann
(grow)

b. 1929
American novelist and short story writer

GRILLPARZER, Franz
(grill•part•sir, frahnts)

1791-1872
Austrian dramatist

GUILLÉN, Jorge
(geel•yawn, hoar•hay)

b. 1893
Spanish poet

GUITRY, Sacha
(gee [as in geek]•tree, saw•shaw)

1885-1957
French dramatist, producer and actor

HANDKE, Peter
(hond•kuh, pay•ter)

b. 1942
Austrian novelist and dramatist

HARTOG, Jan de
(har•tock, yawn)

b. 1914
Dutch-English playwright and novelist

HAVEL, Václav
(haw•vul)

b. 1936
Czech dramatist, essayist and poet

HEARN, Lafcadio
(laugh•kay•dio)

1850-1904
Irish-Greek writer

HÉBERT, Anne
(ay•bare)

b. 1916
French-Canadian poet, novelist and playwright

HEIJERMANS, Herman
(higher•mons)

1864-1924
Dutch novelist, journalist and playwright

HEINE, Heinrich
(hine•uh, hine•rick)

1797-1856
German poet

HESSE, Herman
(hess•uh)

1877-1962
German-Swiss novelist and poet

HUYSMANS, Joris Karl
(oo•ease•mons)

1848-1907
French novelist and art critic of Dutch descent

IONESCO, Eugène
(ee•oh•ness•co, oo•zhen)

b. 1912
Romanian-born playwright

JARREL, Randall
(jair•ul)

1914-1965
American poet

JARRY, Alfred
(zhah•ree, all•fred)

1873-1907
French dramatist, poet and humorist

KAFKA, Franz
(cough•ka)

1883-1924
Czech novelist

KAZIN, Alfred
(kay•zin)

b. 1915 American literary critic, editor and autobio

KESEY, Ken
(key•zee)

b. 1935
American novelist

KOESTLER, Arthur
(kest•lur)

1905-1983
Hungarian-born novelist and science writer

KOSINSKI, Jerzy
(kuh•zin•ski, yur•zee)

b. 1933
Polish-born novelist

KUNDERA, Milan
(coon•dura, me•lawn)

b. 1929
Czech novelist

LOCHHUTH, Rolf
(hawk-hoot)

b. 1931
German dramatist

MAETERLINCK, Maurice
(mah•tur•lonk, mo•reese)

1862-1949
Belgian poet, dramatist and essayist

MALLET-JORIS, Francoise
(mall•**ay**, zhor•**ee**, frahn•swahz)

b. 1930
Belgian novelist

MALRAUX, André
(mal•**roe**)

1901-1976
French novelist

MAMET, David
(**ma**•mit)

b. 1947
American playwright

MARQUEZ, Garcia
(**mar**•kez)

b. 1928
Columbian author and winner of the Nobel Prize for literature

MARSH, Edith Ngaio
(**nigh**•oh)

b. 1899
New Zealand-born detective story writer

MICKIEWICZ, Adam
(**mick**•uh•vich)

1798-1855
Polish poet

MIŁOSZ, Czeław
(**me**•losh, **cres**•love)

b. 1911 Polish poet and novelist,now a naturalized U.S. citizen. Won Nobel prize for literature in 1980.

MISTRAL, Frédéric
(mees•**trawl**, fray•day•**reek**)

1830-1914
French poet

MONTALE, Eugenio
(moan•**taw**•lay, ay•oo•**jen**•yo)

b. 1896 Italian essayist and poet, winner of the Nobel Prize for literature in 1975

MONTHERLANT, Henri de
(moan•tare•**lawn**)

1896-1972
French novelist and dramatist

MUSSET, Alfred de
(mew•**say**)

1810-1857
French poet and playwright

NOBOKOV, Vladimir
(na•**baw**•cawv, vlud•**ee**•mir)

1899-1977
Russian-born novelist

NAIPAUL, V.S.
(nigh•paul)

b. 1932
Trinidad-born novelist of Indian parentage

NIN, Anaïs
(an•i•eece)

1903-1977
American novelist and diarist

O'FAOLAIN, Sean
(oh•**fall**•un, shawn)

b. 1900
Irish novelist and short story writer

ORTEGA Y GASSET, José
(or•**tay**•gah ee gah•**set**)

1883-1955
Spanish essayist and philosopher

PAGNOL, Marcel
(pawn•**yoll**)

1895-1974
French dramatist, film writer and director

PATER, Walter
(pay•tur)

1839-1894
British literary critic and essayist

PAZ, Octavio
(paws)

b. 1914
Mexican poet, essayist and literary critic

PEPYS, Samuel
(peeps)

1633-1703
English diarist and public servant

PERSE, Saint-John
(pairs)

1887-1975 French poet and diplomat who won the Nobel
Prize for literature in 1960. Real name: Alexis Saint-Leger Leger

PETRARCH
(pea•trark)

1304-1374
Italian poet and scholar

PROUST, Marcel
(proost)

1871-1922
French novelist

RABELAIS, Francois
(rab•lay)

1494-1553
French satirical novelist

RAND, Ayn
(ayn rhymes with nine)

1905-1983 Russian-born American novelist,
dramatist and essayist

REMARQUE, Erich Maria
(ruh•mark)

1898-1970
German-born novelist

RHYS, Jean
(reece)

1894-1979
English novelist

RILKE, Rainer Maria
(rill•cuh, rye•nur)

1875-1926
German poet

RIMBAUD, Arthur
(ram•bo)

1854-1891
French poet

ROBBE-GRILLET, Alain
(robe•gree•ay)

b. 1922
French novelist and screenwriter

ROETHKE, Theodore
(ret•cuh)

1908-1963
American poet

ROMAINS, Jules
(roe•man)

1885-1972 French playwright and novelist.
Real name: Louis Farigoule

ROY, Gabrielle
(rwah)

b. 1909
French-Canadian novelist

SAINTE-BEUVE, Charles Augustin
(sant•buv, sharl)

1804-1869
French literary critic

SAKI
(saw•key)

1870-1916 Pen name for Hector Hugh Munro.
British satirist and humorist

SARRAUTE, Nathalie
(saw•**rote**)

> *b. 1902*
> *Russian-born French novelist and playwright*

SARTRE, Jean Paul
(**sahr**•truh)

> *1905-1980*
> *French philosopher, social critic and author*

SCRIBE, Augustin
(screeb)

> *1791-1861*
> *French playwright*

SHAFFER, Peter
(**shaf**•ur)

> *b. 1926*
> *British dramatist*

SILONE, Ignazio
(see•**low**•nay)

> *1900-1978 Pen name of Secondo Tranquilli,*
> *Italian novelist and anti-Facist activist*

SOLZHENITSYN, Aleksandr
(soul•zhuh•**neet**•sin)

> *b. 1918 Expatriate Russian novelist, winner of the*
> *Nobel Prize for literature*

STAËL, Madame de
(stall)

> *1766-1817*
> *Swiss-French novelist and literary critic*

STENDHAL
(stan•**doll**)

> *1783-1842*
> *Pen name of Henri Marie Beyle, French novelist*

STRACHEY, Lytton
(**stray**•chee, littun)

> *1880-1932*
> *English biographer*

SYNGE, John Millington
(sing)

1871-1909
Irish playwright

TALESE, Gay
(tal•ease)

b. 1932
American reporter and author

THOMAS, Dylan
(dillon)

1914-1953
Welsh poet

TOCQUEVILLE, Alexis de
(toke•veal)

1805-1859
French author of Democracy in America

TOLKIEN, J.R.R.
(toll•keen)

1892-1973
British author

TRAVEN, B.
(trah•ven)

1890-1969 Pen name of Berick Traven Torsvan,
American-born novelist

TUCHMAN, Barbara
(tuck•man)

b. 1912
American historian, winner of two Pulitzer Prizes

TURGENEV, Ivan
(tour•gain•yif)

1818-1883
Russian novelist and short story writer

VALÉRY, Paul
(vuh•lay•ree)

1871-1945
French poet

VARGAS LLOSA, Mario
(yosa)

b. 1936
Peruvian novelist

VERLAINE, Paul
(vair•len)

1844-1896
French poet

VILLON, Francois
(vee•yohn)

1431-1463
French poet

WEISS, Peter
(vice)

b. 1916
German playwright, novelist and film director

WERFEL, Franz
(vair•full)

1890-1945
Austrian novelist and playwright

WIESEL, Eliezer "Elie"
(we•zell)

b. 1928
Romanian-born American author

WOUK, Herman
(wohk)

b. 1915
American novelist

YEATS, William Butler
(yatcs)

1865-1939
Irish poet and dramatist

ZWEIG, Stefan
(tsvike)

1881-1942
Austrian writer

Music and Dance

ALBANESE, Licia
(all•bah•**nay**•zay, **lee**•chaw)

b. 1913
Italian-American soprano

ARRAU, Claudio
(rhyms with allow)

b. 1903
*Chilean pianist (Spanish: are **rab**•oo)*

BACH, Johann Sebastian
(bock)

1735-1782
German composer

BACKHAUS, Wilhelm
(**bock**•hows)

1884-1969
German pianist

BALANCHINE, George
(**bal**•uncheen)

1904-1983
Russian-born choreographer

BARYSHNIKOV, Mikhail
(buh•**rish**•knee•cough, meek•hyle)

b. 1948
Latvian-born ballet dancer and director

BERNSTEIN, Leonard
(burn•stine)

b. 1918
American composer and conductor

BÖHM, Karl
(burm [preferably with a silent r])

1894-1981
Austrian conductor

BOIELDIEU, Francois Adrien
(bwall•dee•oo)

1775-1834
French opera composer

BOITO, Arrigo
(bo•ee•toe)

1842-1918
Italian composer and librettist

BOULEZ, Pierre
(boo•lez)

b. 1925
French composer and conductor

BRUCH, Max
(brook)

1838-1920
German composer

BRUHN, Erik
(broon)

b. 1928
Danish ballet dancer and director

BUJONES, Fernando
(boo•hoe•nays)

b. 1955
American ballet dancer

BUXTEHUDE, Dietrich
(bucks•tuh•hoo•dee)

1637-1707
Danish-born organist and composer

CASADESUS, Robert
(caw•saw•duh•sue, ro•bare)

1899-1972
French pianist and composer

CASTELNUOVO-TEDESCO, Mario
(tay•days•co)

1895-1968
Italian-American composer

CHABRIER, Emmanuell
(shaw•bree•**ay**)

1841-1894
French composer

CHALIAPIN, Fyodor Ivanovich
(shawly•**awp**•in)

1873-1938
Russian basso

CHAMINADE, Cécile
(shaw•me•**nod**)

1857-1944
French pianist and composer

CHARPENTIER, Gustave
(shar•pon•**tee/ay**)

1860-1956
French composer

CHAUSSON, Ernest
(show•**sawn**)

1855-1899
French composer

CHÁVEZ, Carlos
(**shaw**•vays)

1899-1978
Mexican composer

CHERUBINI, Luigi
(care•oo•**beanie**)

1760-1842
Italian composer

CILEÁ, Francesco
(chee•**lay**•ah)

1866-1950
Italian composer

CIMAROSA, Domenico
(chee•ma•**row**•zah)

1749-1801
Italian opera composer

CORTOT, Alfred
(core•**toe**)

1877-1962
French pianist

COUPERIN, Francois
(coo•per•**an**)

1668-1733
French composer and organist

CZERNY, Carl
(**chair**•knee)

1791-1857
Austrian composer, pianist and teacher

d'AMBOISE, Jacques
(dahm•**bwahz**)

b. 1934
American ballet dancer

DANILOVA, Alexandra
(da•**knee**•lowva)

b. 1904
Russian-born ballerina and teacher

DAVID, Félicien César
(daw•**veed**, fay•lee•see•**an**)

1810-1876
French composer

DEBUSSY, Claude
(deb•you•see)

1862-1918
French composer

DELIBES, Léo
(duh•**leeb**, **lay**•oh)

1836-1891
French composer

DELLO JOIO, Norman
(joyo)

b. 1913
American composer

DIAGHILEV, Serge Pavlovich
(dee·ah·gill·**yeff, sir·gay)**

1872-1929
Russian ballet impressario

DIMITROVA, Ghena
(dee•**me**•trova, gaina)

b. 1941
Bulgarian soprano

DOHNÁNYI, Ernst von
(daw·**non**·yee, airnst fan)

1877-1960
Hungarian composer, pianist and teacher

DVOŘÁK, Antonin
(dvor·zhock)

1841-1904
Bohemian composer

FALLA, Manuel de
(fah·yuh)

1876-1946
Spanish composer

FAURÉ, Gabriel Urbain
(for·**ay**, gah·bree·**el** your·**ban**)

1845-1924
French composer

FISHER-DIESKAU, Dietrick
(fisher **deese**·cow, deet·rick)

b. 1925
German baritone

FOSS, Lukas
(faws)

b. 1922 German-born American composer,
conductor and pianist

FRACCI, Carla
(fraught·chee)

b. 1936
Italian ballerina

FRANCESCATTI, Zion Rene
(fron•chess•**cot**•ee)

b. 1905
French violinist

FRANCK, César
(fronk, say•**zar**)

1822-1890
Belgian composer

FURTWÄNGLER, Wilhelm
(**foort**•veng•glur)

1886-1954
German conductor

GIGLI, Beniamino
(**jeel**•yee, ben•yah•**mean**•oh)

1890-1957
Italian tenor

GINASTERA, Alberto
(hee•nah•**stay**•rah)

b. 1916
Argentine composer

GIORDANO, Umberto
(johr•**don**•o)

1867-1948
Italian composer

GLIÈRE, Rheinhold Moritzovich
(glee•**air**)

1875-1956
Russian composer and conductor

GODUNOV, Aleksandr
(**go**•duh•noff)

b. 1950
Soviet dancer who defected to the U.S. in 1979

GOUNOD, Charles
(goo•**no**)

1818-1893
French composer

HAITINK, Bernard
(high•tink)

b. 1929
Dutch conductor

HALÉVY, Jacques
(ah•lay•vee)

1799-1862
French composer

HAYDN, Franz Josef
(high•dn)

1732-1809
Austrian composer

HENZE, Hans Werner
(hent•see, hahns, •vair•nur)

b. 1926
German composer

HONNEGGER, Arthur
(oh•nay•gair, artoor)

1892-1955
French composer

IBERT, Jacques
(ee•bare)

1890-1962
French composer

d'INDY, Vincent
(dan•dee, van•sawn)

1855-1931
French composer

ITURBI, José
(ee•tour•bee, hoe•zay)

b. 1895
Spanish-born pianist and conductor

JANÁČEK, Leoš
(yawn•ah•check, lay•ohsh)

1854-1928
Czech composer

JERITZA, Maria
(yuh•**rits**•uh)

b. 1887
Czech soprano

JOACHIM, Joseph
(**yoh**•ah•kim, **yoh**•sef)

1831-1907
Hungarian violinist and composer

JOLIVET, André
(zhoh•lee•vay, on•**dray**)

1905-1974
French composer

JOOSS, Kurt
(yohs, coort)

1901-1979
German choreographer

KARAJAN, Herbert Von
(**car**•ah•yawn)

b. 1908
Austrian conductor

KÖCHEL, Ludwig Ritter von
(curshle [preferably with a silent r])

1800-1877 Austrian music bibliographer who
catalogued Mozart's works

KODÁLY, Zoltán
(**co**•dye)

1882-1967
Hungarian composer

KREUTZER, Rodolphe
(crut•**sair**)

1766-1831 French violinist and composer of
German extraction

LALO, Édouard
(law•**low**)

1823-1892
French composer

LIFAR, Serge
(lee•**far**, sir•gay)

b. 1905
Russian-born dancer and ballet master

LULLY, Jean Baptiste
(loo•**lee**)

1632-1687
Italian-born French composer

MASCAGNI, Pietro
(mahs•**con**•yee)

1863-1945
Italian composer

MESSIAEN, Olivier
(messy•**on**, oh•liv•ee•**ay**)

b. 1908
French composer

MILHAUD, Darius
(me•**oh**)

1892-1974
French composer

MUNCH, Charles
(moonsh, sharl)

1891-1968 German-born orchestra conductor long
associated with the Boston Symphony Orchestra

NIJINSKA, Bronislava
(knee•**zhin**•ska)

1891-1972 Russian-born ballet dancer and
choreographer, sister of Vaslav

NIJINSKY, Vaslav
(knee•**zhin**•ski)

1888-1950
Russian-born ballet dancer and choreographer

NUREYEV, Rudolf
(nuh•**ray**•ef)

b. 1938
Russian-born ballet dancer

SZIGETI, Joseph
(**sig**•etty)

1892-1973
Hungarian-born American violinist

SZYMANOWSKY, Korol
(shim•on•**off**•ski)

1882-1937
Polish composer

VARÈSE, Edgar
(vah•**rez**)

1883-1965
French composer

VIEUXTEMPS, Henri
(view•**tom**)

1820-1881
Belgian composer and violinist

VILLA-LOBOS, Heitor
(vee•lah•**loh**•bohsh, **ay**•tore)

1887-1959
Brazilian composer

WALDTEUFEL, Charles Emile
(**vald**•toy•full)

1837-1915
French composer and pianist

WEBER, Carl Maria von
(**vay**•bur)

1786-1826
German composer

WEBERN, Anton von
(**vay**•burn)

1883-1945
Austrian composer

WEINBERGER, Jaromír
(**wine**•bare•gur)

1896-1967
Czech composer

WEINGARTNER, Felix
(vine•gartner)

1863-1942
Austrian conductor

WIENIAWSKI, Henri
(veen•yohf•ski)

1835-1880
Polish violinist and composer

WOLF-FERRARI, Ermanno
(volf•fay•rah•ree)

1876-1948
Italian opera composer

Painting

BAROCCI, Federico
(bah•**rot**•chee)

1535-1612
Italian painter

BAZILLE, Frederic
(bah•**zee**)

1841-1870
French painter

BENOIS, Aleksandr Nikolayevich
(ben•**wah**)

1870-1950 Russian painter best known as a
costume and set designer for the Ballets Russes

BÖCKLIN, Arnold
(**burk**•lin)

1827-1901
·Swiss artist

BRAQUE, Georges
(brock)

1882-1963
French painter

BRUEGEL, Peter the Elder
(**broy**•gull)

1525-1569
Flemish painter

CAILLEBOTTE, Gustave
(caw•yuh•**but**)

1848-1894
French painter and art patron

CARAVAGGIO, Michelangelo Merisi da
(cara•**vah**•joe)

1573-1610
Italian painter

CASSATT, Mary
(kuh•**sat**)

1847-1926
American painter

CÉZANNE, Paul
(say•**zahn**)

1839-1906
French painter

CHAGALL, Marc
(shaw•**gall**)

1889-1985
Russian-born painter and designer

CHIRICO, Georgio
(**key**•ree•co, jorjoe)

1888-1978
Italian painter

CIMA da Conegliano
(**chee**•ma)

1459-1517
Italian painter

CIMABUE
(chee•ma•**boo**•ay)

1240-1302
Italian painter. Real name: Cenni de Pepi

CLAESZ, Pieter
(claws)

1597-1661
Dutch painter

COCTEAU, Jean
(cock•**toe**)

1889-1963 French novelist, playwright, poet,
painter, designer and film maker

COROT, Jean Batiste Camille
(co•**roe**)

1796 1875
French painter

CORREGGIO
(co•**red**•joe)

1489-1534
Italian painter. Real name: Antonio Allegri

COURBET, Gustave
(coor•**bay**)

1819-1877
French painter

COUTURE, Thomas
(coo•**tour**)

1815-1879
French painter

COZENS, Alexander
(cousins)

1717-1786
English landscape painter

CRANACH, Lucas the Elder
(**craw**•knock)

1472-1553
German painter

CUYP, Aelbert
(coyp, **al**•bairt)

1620-1691
Dutch painter

DAUBIGNY, Charles Francois
(doe•been•**yee**)

1817-1878
French painter

DAUMIER, Honoré
(dome•ee•**ay**)

1808-1879
French painter and sculptor

DAVID, Jacques Louis
(daw•veed)

1748-1825
French painter

DEGAS, Edgar
(duh•**gah**)

1834-1917
French painter

DELACROIX, Eugéne
(de•law•**qua**)

1798-1863
French painter

DELAUNAY, Robert
(duh•low•**nay**, **row**•bare)

1885-1941
French painter

DELVAUX, Paul
(dell•vo)

b. 1897
Belgian painter

DEMUTH, Charles
(**day**•mooth)

1883-1935
American artist

DENIS, Maurice
(duh•**knee**)

1870-1943
French painter

DERAIN, André
(duh•**ran**)

1880-1954
French painter

DIEBENKORN, Richard
(**dee**•ben•corn)

b. 1922
American painter

DORÉ, Gustave
(door•**ay**, goose•tahv)

1832-1883 French artist famous for
wood engraving, illustration

DUBUFFET, Jean
(do•boo•**fay**)

1901-1985
French painter

DUCHAMP, Marcel
(do•**shom**)

1887-1968
French painter

DUFY, Raoul
(do•**fee**, rah•ool)

1887-1953
French painter

DÜRER, Albrecht
(**dyur**•ur, all•brekt)

1471-1528 German artist famous for his
woodcuts and engravings

ERTÉ
(air • **tay**)

b. 1892 Romain de Tirtoff
Russian-born French artist

FANTIN-LATOUR, Henri
(fawn•**tan** law•**tour**)

1836-1904
French painter

FEININGER, Lyonel
(fie•ning•ur)

1871-1956
American artist

FEUERBACH, Anselm
(**foy**•ur•bock, **on**•selm)

1829-1880
German painter

FRAGONARD, Jean Honoré
(fraw•go•**nar**)

1732-1806
French painter

GAUGIN, Paul
(go•**gan**)

1848-1903
French painter

GAULLI, Giovonni Battista
(gah•**ool**•lee)

1639-1709
Italian painter

GÉRICAULT, Théodore
(zhay•re•**co**, tay•o•**door**)

1791-1824
French painter

GÉRÔME, Jean Léon
(zhay•**roam**, zhon, **lay**•on)

1824-1904
French painter

GIORGIONE
(johr•**joan**•ay)

1477-1510
Italian painter

GIOTTO di Bondone
(**joht**•toe, dee bon•**doc**•nay)

1267-1337
Italian painter

GIOVANNI DI PAOLO
(joe•**vah**•knee)

1403-1482
Sienese painter

GLEIZES, Albert
(glez)

1881-1953
French designer and painter

GOGH, Vincent van
(van•go)

1853-1890
Dutch painter

GRIS, Juan
(grees, whon)

1887-1927
Spanish painter

GROS, Antonie Jean, Baron
(grow)

1771-1835
French painter

GROSZ, George
(gross)

1893-1959
German-American painter

GUÉRIN, Pierre Narcisse, Baron
(gay•ran)

1774-1833
French painter

GUYS, Constantin
(goys)

1805-1892
French painter

HABERLE, John
(haberly)

1856-1933
American painter

HALS, Frans
(halls, frons)

1580-1666
Dutch painter

HECKEL, Erich
(heckle, ay•rick)

1883-1970
German painter

HÉLION, Jean
(ale•yon)

b. 1904
French painter

HEYDEN, Jan Van der
(high•din)

1637-1712
Dutch painter

HOLBEIN, Hans, the Elder
(hole•bine)

1465-1524
German painter

HOOCH, Pieter de
(hock)

1629-1684
Dutch painter

INGRES, Jean Auguste Dominique
(ang•gruh)

1780-1867
French painter

JAWLENSKY, Alexey von
(yow•len•ski)

1864-1941
German expressionist painter

KANDINSKY, Wassily
(kun•dean•ski, vah•see•lee)

1866-1944
Russian-born painter

KIENHOLZ, Edward
(keen•holtz)

b. 1927
American artist

KLEE, Paul
(clay)

1879-1940
Swiss-born painter

KLIMT, Gustav
(kleemt)

1862-1918
Austrian painter

KOKOSCHKA, Oskar
(co•**cosh**•kuh, **ohs**•kur)

1896-1980
Austrian-born painter, poet and playwright

KOLLWITZ, Käthe
(**cawl**•vits, **kay**•tuh)

1867-1945
German graphic artist

LANDSEER, Sir Edwin
(**lan**•seer)

1802-1873
English painter

LÉGER, Fernand
(lay•**zhay**, fair•**non**)

1881-1955
French painter

LICHTENSTEIN, Roy
(**lick**•ten•steen)

b. 1923
American artist

LURCAT, Jean
(lure•**sah**, zhawn)

1892-1966
French painter and designer

MAGRITTE, René
(muh•**greet**)

1898-1967
Belgian painter

MANET, Édouard
(maw•**nay**, ay•**dwahr**)

1832-1883
French painter

MARISOL
(**mare**•eye•sull)

b. 1930 American pop artist of Venezuelan
ancestry. Full name: Marisol Escobar

MICHELANGELO
(mickle•**an**•jullo)

1475-1564 Italian sculptor and painter.
Last name: Buonarotti

MILLAIS, Sir John Everett
(mill•ay)

1829-1896
British painter

MILLET, Jean Francois
(me•**lay**)

1814-1875
French painter

MINNE, George
(min, zhorzh)

1866-1941
Belgian painter and sculptor

MIRÓ, Joan
(me•**roe**, hoe•**on**)

1893 1983
Spanish painter

MODIGLIANI, Amadeo
(mo•deal•ee•**ah**•knee)

1884-1920
Italian painter and sculptor

MOHOLY-NAGY, Lãzló
(**mo**•holy•**nod**•yuh, laws•low)

1895-1946 Hungarian-born painter, sculptor,
stage designer, photographer and film maker

MONDRIAN, Piet
(**moan**•dree•on, peet)

1872-1944
Dutch painter

MONET, Claude
(mow•**nay**, cload)

1890-1926
French painter

MORISOT, Berthe
(more•**ee**•zoh, bairt)

> *1841-1895 French painter, the first woman associated with Impressionism*

MUNCH, Edvard
(moonk, **ed**•vart)

> *1863-1944*
> *Norwegian painter*

PAOLOZZI, Eduardo
(pow•**lot**•see)

> *b. 1924*
> *Scottish artist*

PECHSTEIN, Max
(**peck**•shtine)

> *1881-1955*
> *German painter and print maker*

PEREIRA, I. Rice
(puh•**ray**•ruh)

> *1907-1971*
> *American painter*

RAPHAEL
(rah•fah•**el**)

> *1483-1520*
> *Italian painter*

RAUSCHENBERG, Robert
(**row** [as in brow]•shan•burg)

> *b. 1925*
> *American artist*

ROUAULT, George
(roo•**oh**)

> *1871-1958*
> *French painter*

SCHIELE, Egon
(**she**•luh)

> *1890-1918*
> *Austrian painter*

SCHWITTERS, Kurt
(**shvit•**urs)

1887-1948
German artist

SEURAT, George
(sir•**ah**)

1859-1891
French painter

SIGNAC, Paul
(seen•yawk)

1863-1935
French painter

SISLEY, Alfred
(sees•**lay**)

1839-1899
French painter

SOULAGES, Pierre
(sue•**lawzh**)

b. 1919
French painter

SOUTINE, Chaim
(sue•**teen**, kye•im)

1893-1943
Russian-born painter

TANGUY, Yves
(tawn•**gee** [as in geek], eve)

1910-1955
French painter

TOULOUSE-LAUTREC, Henri de
(too•**looz**, low•**trek**)

1864-1901
French artist

UTRILLO, Maurice
(oo•**tree•**oh)

1883-1955
French painter

VAN GOGH, Vincent
 (van go)

1853-1890
Dutch painter

VASARELY, Victor
 (vah•zah•ray•**lee**)

b. 1908
Hungarian artist

VELÁZQUEZ, Diego
 (vay•**lawth**•kayth)

1599-1660
Spanish painter

VERMEER, Jan
 (ver•**mayr**)

1632-1675
Dutch painter

VERONESE, Paolo
 (vay•roh•**nay**•zay)

1528-1588
Italian painter

VUILLARD, Édouard
 (vwee•**yar**)

1868-1940
French artist

Sculpture

BARLACH, Ernst
(**bar**•lock)

1870-1939
German sculptor, artist and dramatist

BARTHOLDI, Frédéric Auguste
(bar•toll•**dee**)

1834-1904
French sculptor

BARYE, Antoine Louis
(bar•**ree**)

1796-1875
French sculptor

BERTOIA, Harry
(bare•**toy**•uh)

1915-1978
Italian-born American sculptor

BRANCUSI, Constantin
(brong•**coo**•zee)

1876-1957
Rumanian-born sculptor

CARO, Anthony
(**car**•o)

b. 1924
English sculptor

CELLINI, Benvenuto
(chell•**lee**•knee)

1500-1571
Italian sculptor, goldsmith, architect and writer

CÉSAR
(say•**zar**)

b. 1924
French sculptor. Christened César Baldaccini

COYSEVOX, Antoine
(quaz•**vo**)

1640-1720
French sculptor

DAUMIER, Honoré
(dome•ee•**ay**)

1808-1879
French painter and sculptor

FALCONET, Étienne Maurice
(fall•co•**nay**)

1716-1791
French sculptor

FLAVIN, Dan
(**flay**•vin)

b. 1933 American artist famous for abstract neon sculptures

GABO, Naum
(**gah**•bo, nowm)

1890-1977
Russian-American sculptor, painter and architect

GARGALLO, Pablo
(gar•**gall**•yo)

1881-1934
Spanish sculptor

GAUDIER-BRZESKA, Henri
(go•dee•**ay**, bur•zes**ka**)

1891-1915
French sculptor

GÉRÔME, Jean Léon
(zhay•**roam**, zhon, **lay**•on)

1824-1904
French painter and sculptor

GHIBERTI, Lorenzo
(gee [as in geek]•bare•tee)

1381-1455
Italian sculptor

GIACOMETTI, Alberto
(jacko•**met**•tee)

1901-1966
Swiss sculptor

GOERITZ, Mathias
(**gur**•its)

b. 1951
German sculptor and architect living in Mexico

GROSS, Chaim
(kime)

b. 1904
Czech-born American sculptor

HILDEBRAND, Adolph von
(**hilda**•bront)

1847-1921
German sculptor

KOLBE, Georg
(**coal**•buh, gay•**ork**)

1877-1947
German sculptor

LIPCHITZ, Jacques
(leep•**sheets**, zhock)

1891-1973
Lithuanian-born French sculptor

MAILLOL, Aristide
(my•**ohl**, ar•ees•**teed**)

1861-1944
French sculptor and graphic artist

MICHELANGELO
(mickle•**an**•jullo)

1475-1564 Italian sculptor and painter.
Last name: Buonarotti

MILLES, Carl
(**mill**•iss)

1875-1955
Swedish-American sculptor

MINNE, George
(min, zhorzh)

1866-1941
Belgian painter and sculptor

MODIGLIANI, Amadeo
(mo•deal•ee•ah•knee)

1884-1920
Italian painter and sculptor

MOHOLY-NAGY, Lázló
(mo•holy•nod•yuh, laws•low)

1895-1946 Hungarian-born painter, sculptor,
stage designer, photographer and film maker

ROSZAK, Theodore
(raw•shock)

b. 1907
American sculptor and painter

STANKIEWICZ, Richard
(stang•key•e•vich)

b. 1922
American sculptor

TINGUELY, Jean
(tan•glee)

b. 1925
Swiss sculptor

Index

By alphabetical order

Graphic Design by:
Herman Design Group, Inc.

Typeset by: Dyna-Type,
Detroit, Michigan
in Garamond Bold Condensed
and Garamond Book Cond. Italic
Litho in U.S.A.